even the least of
these

even the least of these

poems by Anita Skeen
prints by Laura B. DeLind

MICHIGAN STATE UNIVERSITY PRESS | East Lansing

Michigan State University Press
East Lansing, Michigan 48823-5245

Library of Congress Cataloging-in-Publication Data
Names: Skeen, Anita, author. | DeLind, Laura B. (Laura Barwicke), illustrator.
Title: Even the least of these : poems by Anita Skeen ;
prints by Laura B. DeLind.
Description: East Lansing : Michigan State University Press, 2024.
Identifiers: LCCN 2023032386 | ISBN 9781611864915 (paper) | ISBN
9781609177607 (PDF) | ISBN 9781628955224 (ePub)
Subjects: LCGFT: Poetry.
Classification: LCC PS3569.K374 E94 2024 | DDC 811/.54—dc23/eng/20230713
LC record available at https://lccn.loc.gov/2023032386

Book design by Anastasia Wraight
Cover design by Allyson Davidson
Cover art by Laura B. DeLind

Visit Michigan State University Press at www.msupress.org

Contents

Preface

For most of us, our lives changed dramatically in the COVID years. We could no longer go to our places of work, our children remained home and away from friends, we couldn't see or touch or hug the people we love, we did not go to restaurants or to houses of worship, we had our groceries delivered. We lost a lot. But there was, or could be, a silver lining to this dark cloud: we had time, if we took it, to notice the small things we missed in the normal pace of our frantic pre-pandemic lives. There were treasures around us we had left undiscovered. There were small moments of joy that were more important now than they had been. There were memories we had time to resurrect, plans to be made for the future.

My acquaintance with the ten-line poem grew out of an assignment I gave to folks who had been in my fall 2018 writing class, "Singing in the Dark Times, " at Ghost Ranch in Abiquiu, New Mexico. Since that time we've done a number of things to stay connected, one of which was having everyone who had been in the class, who had the time, respond with a poem to a prompt I offered the group: "Write a poem of ten lines." As COVID-19 cases were on the rise at the beginning of 2020, and the governor of Michigan issued stay-at-home mandates, I decided that one of the ways I would stay grounded during this unprecedented (a very overused word these days) time was to try to write a ten-line poem every day. I wanted to notice the small things I would have missed in the normal pace of those frantic pre-pandemic days. I wanted to pay a small tribute to elements and creatures in the natural world, events that were happening, memories that resurfaced for some reason, quirks in language, and, yes, the miracles that I knew were out there every day and that I, too, often missed. I looked through the work of many poets whom I thought would have ten-line poems, surely: James Wright, William Carlos Williams, William Stafford, Mary Oliver, Ted Kooser, Lisel Mueller, Jane Kenyon, Gwendolyn Brooks, Rita Dove, Mark Doty, Kay Ryan, Naomi Shihab Nye, and on and on. But not that many ten-line poems turned up.

To my way of thinking, the ten-line poem is not something you should work on for hours and hours and hours (maybe just hours and hours?). Its purpose is to capture something you don't want to forget, something that surprised you, something that makes a larger connection for you. There are also in this collection twenty-line poems—they operate on the same principle as the double sonnet, which has twenty-eight lines rather than fourteen. I would call the ten-line poem a nonce form, that is, a form that is made up for the moment and for a particular purpose. I created this form for brevity, spareness, and clarity, because I wanted to write poems about the small, ordinary things that, in our busy, non-quarantined lives, we never pay attention to. My hope is that in reading this collection of poems, you, too, will want to take up the ten-line poem, to try to capture and preserve the all-too-fleeting moments in our lives when something flashes by, and we let it go. Don't let go of it: preserve it in the ten-line poem.

—*Anita Skeen*

Collaborating with Anita has always been a joyful experience. We've taught classes together, produced a book together, and traveled to Vancouver and West Virginia together. But in the late spring of 2020 and throughout that difficult year, our collaboration was far more than joyful; it literally kept me from losing my way.

Like so many other people, I had plans for 2020. I was scheduled to teach printmaking workshops in Costa Rica, at Ghost Ranch in New Mexico, and at home in Mason, Michigan. Art fairs, gallery shows, and seasonal holiday events were planned throughout what was clearly going to be a very busy and artistically affirming year. I was excited and (to be honest) proud of myself and my emerging identity as an artist. After all, I'd been an academic for over thirty-five years—and now I had become something quite different, something that depended on the right

side of my brain rather than the left. But 2020 and COVID-19 didn't care how I may have reinvented myself or which side of my brain I wanted to use. All my best-laid plans came crashing down. Self-isolation became the norm. Travel, public appearances, teaching, and printmaking were displaced by confusion, anxiety, and uncertainty. It wasn't long before I found myself adrift—seemingly without projects or purpose. I was wandering rudderless in a very dark place. This is when Anita's ten-line poems came to the rescue.

Challenging herself to write one ten-line poem a day as a way of coping with COVID's tyranny, Anita, in turn, challenged me. Almost every day, I found a new poem in my inbox with an invitation to design a complementary print. I couldn't keep up with the words, but I did create a suite of over twenty-five prints, and the process was invigorating. I was once again using my skills in an artful and graceful way—COVID be damned. I also was reflecting on some things that I hadn't fully considered before. I now had time to appreciate the fact that there are many ways to survive in a less than perfect world, and that art and artistic expression through dance and music, poetry and literature, and the visual and other arts—far from being irrelevant—are critical to that survival. Likewise, I had time to appreciate the value of collaboration as a chord of connection and affection despite physical distance. Such things should not go unnoticed.

—*Laura B. DeLind*

even the
least of
these

Even the Least of These

I tell my friend Emily that I'm trying to save
an injured fish in my pond, one that lies flat

on the bottom, one who has lost the ability
or desire to swim. Other fish huddle over him

on cold nights; one lies against him, in sunlight.
I say to Emily, "How can you love a fish?"

She tells me how, in childhood, she rescued
worms, big ones after big rains. She set up

a worm hospital, freed them from being bait:
"There was something there I needed to save."

My Body, When I Was a Girl

was a tree, hardwood, rings
rolling out toward the years,
branches full of nests, singing.
I was the spring in the woods,
box turtles buried in cool mud,
alert to snap down on curious
toes. I was the late evening
light turning to dark, softening
our faces to voices, ghosting us,
bodies dissolved, only words.

Right on Schedule

Poems will fly Friday.
 —Jane Taylor

Tomorrow, the poems will leave their nests,
their burrows, their hidey-holes behind the sheds.
You may hear flapping of paper in the crepuscular
hours of morning as they assemble their letters
into words, words into lines, lines into stanzas.
They like to get off early. Others, the late risers,
avoid the heat of the day, departing their notebooks
in after-dinner hours, swooping with bats above trees.
Be alert. Rise early, retire late, or you will miss them.
If page 49 is gone, wait a day, then return after dark.

Every So Often

In the dream, three of us squeeze
into a tiny car (foreign, I'm told),
one woman I never met before,
another one I loved to heartbreak,
my shoulder pressed against hers,
thighs side by side. Oh, Memory,
how can you feel back across fifty
years, the heat of our bodies waking
me in this dark night, my stomach
dropping to the floorboards.

Contemporary Ornithology

And Adam gave names to all cattle, and to the fowl of the air,
and to every beast of the field . . .
> —Genesis 2:20

Sedona, who is thirteen, sends me a photo:
I made a birdfeeder with my dad
and this is Chuck, she writes. He looks
to be a purple finch, though she knows
him only as Chuck. I tell her about
the redwing blackbird who sings his way
to my feeder, say I will send a photo,
wish I could send the song. I ask
what I should name him. *I love watching*
the birds, she answers. *Maybe Charlie.*

Redbud

It's a tree on fire, lavender lighting up
the stand of spruce behind it,
red–purple buds snowing on the sharp
green needles so that they, too,
appear about to flame. Standing
beneath the branches, looking up
to the absolute blue sky, I see
constellations unknown to night–sky
watchers: Simmering Embers, Joy
Explosion, Handful of Candy.

Into the Woods

On day number who-knows-which
of the shelter-in-place edict,
we go into the woods to stay
sane. In the not-yet-spring
I discover two patches of purple
stalks, future blackberries I can
harvest in July if I am quicker than
deer. We go on though puddles,
brush, pick up slender spruce cones.
Rabbit watches, pussy willow with ears.

Fixing Wall

Even though the snowplow came only
twice this winter, the driver managed
to mangle the low wall bordering
the island garden, scattering heavy
stones hither and yon, as he does every
year. His plow, it seems, will never
love a wall. Every spring, I reconstruct.
It's a jigsaw wall, stones broken, odd shapes
fitted, then moved aside for better choice.
Avoid the crocus, do not smash the worm.

On the Move

I am a worshipper of flowing . . .
—Czeslaw Milosz

Rivers and streams
Tangled lines on a map
Traffic snarling its way home
Cat leaping from the top pod of the tower
Words searching for a story

Blue heron soaring above the lake
Conversation among friends
Letters traveling town to town
Ghost in the house gliding room to room
Words discovering the poem

Walking Song

honeysuckle, blackberry,
elderberry, bird chirp,
birchbark, latticework,
sunlight, bitterroot,
tree root, red dirt,
clover patch, windy
grass, shadow quiver,
blue sky, tiny spider,
big bee, buttercup,
people clutter,

mown grass, dead
branch, black walnut,
woodpecker, red beetle,
pine needles, locust
leaves, dandelion,
May apples, tulip
tree, drooping
dogwood, forest
chatter, sparkling
stone, bleached bone.

Housing Project

In early spring, birds hang out
in the scaffolding of the red maple,
goldfinches high up, construction
workers in neon vests, nuthatches
rappelling upside down on the trunk.
They make a tic-tac-toe of feathers
flitting limb to branch. When scarlet
leaves paper the tree in May, finches
jump into open windows, chickadees
wobble home late, always drunk.

Birds of a Feather

This morning it's the neighborhood
pileated woodpecker knocking
on my deck railing, cleaning his beak
on the iron hook, scanning the sky,
flaring out his red cap as he ducks
incoming finches and sparrows.
Later, three neighborhood chickens
waddle into the yard, chortling over
some private joke. Such unlikely cousins,
these birds, so marvelous, so absurd.

Five and Dime

They were the Macy's and Neiman-Marcus
of my childhood, stores with such an array
of treasure I had a hard time choosing.
If I went window shopping with my grandmother
on Saturday mornings while my mother worked,
we might stop in Woolworth's for a Coca-Cola.
Spinning on the red vinyl stool beneath spinning
overhead fans, I looked down from the mezzanine
at women buying make-up, or notions, or maybe
roasted nuts hot from the lighted machine. Below

this floor, in the basement, were the toys: cap guns,
plastic soldiers and cowboys, Lincoln Logs and Block City,
balls, puzzles, games, play money and trains, too much
space given over to dolls, ones who wet their pants,
ones who cried if you held them upside down, ones
who had more clothes than I did. My cousins liked
to shop that aisle when they came from Parkersburg.
Often, we went to Kresge's or Newbury's or Ben Franklin's
on the Westside. Each had its smell, and the air conditioning
we loved, that first cold blast that took our breaths away.

Song of the Sheets and T-Shirts

Our days and nights of drying, limp
in the basement, hung from pipes

and furnace ducts, are ended.
This first day of Spring we pile

into the basket, pray for a trip
to the clothesline, lonely since late

November, shake out our wrinkles
in the sunlight. Gripped by pins,

hung sleeve to sock to trouser leg,
we are happy flapping, wind-snapped.

That's How It Is These Days

Envy the birds. No social
distancing for them.
These three are blue,
as we are, too, unable
to go out with pals, hang
upside down from any limb
we've found. And what about
that bug? A tick? Without
a dog? Doesn't know where
he ought to be. Do we?

Blizzard, Or Not

It's early July and 90 degrees
in Michigan. Peonies burst their buds,
bleeding hearts say goodbye.
The orioles, who consumed jars
of jam, have abandoned us
for who knows where. I drive
up the blacktop from the highway,
white flurries attacking my windshield,
wooly white trimming the stand of spruce.
Overhead, the cottonwood, frisky with tricks.

Good as Gold

The woods are full of treasures,
I told my grandson, who asked

if I knew where the gold was buried.
No gold, I told him. Disappointed, still

he followed me past the flattened grasses
where the deer sleep, prickly blackberry vines

sporting green knobs, to the small maple I'd replanted,
struggling to grow. I reached down, breaking a brittle leaf.

Out popped a thumb-sized toad, the color of dirt.
That moment, that jolt: jackpot.

Learning about Nuance

I discovered our cat who starts pacing
the house at suppertime and again
in the morning before the sun comes up
is crepuscular, not nocturnal, as I imagined.
She wants out in those in-between hours,
the time when frogs are sleepy on warm rocks
and chipmunks have just begun the hunt for food.
A stray, she turned up in our yard starving, wary
of touch. In life before us, shadows stroked her.
She prowled the world, owning it all.

Chaos in Spring

In April, it's noisy underground,
roots and tubers squabbling
for prime time, shoving up shoots.
Canada geese charge in from the south
barking like a pack of hounds on the trail
of fox, hounds who somehow attain
feathers, somehow acquire the lift
and hubris of Icarus, racing for
the neighborhood pond, splashing
down, arguing who hit water first.

Room of Trees

For John and India

There's a new room in the basement
of your old, restored farmhouse, down
the steps, turn right, walk into the forest
you had to take from the land. A room
of planed walls, board against board, tree
against tree as they must have grown up
together, weathering storms, sheltering
nests, singing leaf song. One window
pulls in the light. At night, you can hear
their slow heartbeats, red pine, white pine.

The Woodchuck

The woodchuck scoots along the fence
where weeds are tall, and grass is dense.

He sees me coming up the trail
and heaves his body, head to tail,

deeper into jungle growth.

Now, there is scrutiny from us both.
I watch him waddle, disappear.

I want to tell him not to fear.
But he has places he must go

regardless if I'm friend or foe.

What Spring Brings

If you look closely, just to the left
of the spears of new water iris
breaking the surface of the pond,
you might see two tiny eyes,
the color of water. Here,
the smallest of seven frogs
taking up residence in the pond,
piling atop each other, green
and brown camouflage among
roots. Lean down. Look. Gone.

The Incredible Incident of the
Cat in the Nighttime

It all started in the morning when the cat bounded
through the front door, streaked down the hall,
chipmunk in her mouth, and lost it, squirming,
in the bedroom doorway. Who knew where
the chipmunk went. The cat couldn't find it,
I couldn't find it with a flashlight, so I gave up,
knowing it would reappear. Which it did,
hightailing it into the study, nowhere to be found.
Hours later, it's bedtime, and we're in the room
with three kittens in a playpen at the foot of the bed.

Enter Mother Cat, who spots the chipmunk right off,
behind the guitar beside the dresser, and ferrets
it out. Now, in her mouth, the chipmunk wriggles,
a death-defying attempt to swim through the air,
as the cat leaps into the playpen with the kittens,
where she drops the chipmunk. Chipmunk burrows
into the blankets, the cat pounces on the lump,
a tsunami of bedlam upends the kittens, crying.
I eject the cat, then extract the chipmunk,
relief for all of us when I open the sliding door.

Pastels

Laundry day, and on top of the pile
of light-colored clothes, two turtlenecks,

side by side, one aqua, one pale yellow.
Caught in the corner of my eye,

the Easter outfits my mother sewed
for us. She loved pastels and florals.

We pose for my father's Brownie
on the cracked sidewalk. Behind us

forsythia explodes, giddy with Spring,
my mother resurrected from winter wools.

Beyond Language

My name is my own my own my own
 —June Jordan

Like a cat, I, too, have a secret
name known only to me,
never spoken, never written,
remembered in blood vessels
and heart pump. An essence
name, not of syllables, not
for signing, a noisy name to crash
the sky like thunder, one soft as
the fur a rabbit tugs from her dewlap
to line the nest for her newborn.

No Wheelbarrow, No Rain

This afternoon, the chickens,
two spotted like static

on the old TV screen
and the red/golden one,

trundle into our yard
from beneath the cedars.

This is our first sighting
since winter kept them home.

Such joy in the fluffing of feathers.
Such happiness trotting on barbed feet.

The Cardinals, the Cat,
and the Chickens

There's commotion in the yard below the deck
where I sit reading, the racket of distressed ducks,
but no ducks live nearby. I go down to check it out,
find the two neighborhood chickens, distraught
over something, which turns out to be the stray cat
they have frightened into the bushes, banshee loud.
Two cardinals join the melee, shrieking at the cat,
swooping in low arcs across the yard, startling
the chickens, who hop like they're on hot coals.
Another day during Stay-at-Home, everyone fidgety.

Morning Glories

Above the stone wall, constellations
of morning glories, blue holes pulling in
morning light, scroll across the slope.
I watch them open early in the day,
how they funnel the ocean of sky
into a language of blue, the silence
of grace. By midday they tire of glory,
tire of their starring role in the yard,
fold into their velvet envelopes
addressed to tomorrow.

The Retired Librarian Suffers the Effects of Coronavirus Isolation

with thanks to Jane Taylor

It's Monday, right? Last night I had a high anxiety
nightmare in which I was working the reference desk

but suddenly realized I was in my pajamas. And no one
else was. Plus I couldn't understand any of the questions

students were asking: *Who won the Noble Prize for
Ignorance in 2020? How do I inject Lysol into my big toe*

to keep from getting sick? Where is Kim Jong Trump?
Can I use my air conditioner as a ventilator?

When I woke up, I ***was*** in my pajamas. Do I have to go
to the library today? Wait, I'm retired. Is it Monday?

Meteorology 101

I understand now why my parents took
those Sunday afternoon naps, dishes
done and the paper read, children
shooed out the door to find someone
else to ask a thousand questions.
There must have been a thousand
sighs go up from the old brown couch
and the chair in front of the baseball
game, heads nodding, Monday rolling in,
gray clouds from the west, turbulence ahead.

Once You Name Them

they're family, the chickens come galloping
from their coop behind the cedars, racing

like track stars on our blacktop driveway,
heading straight for me, as though I were

the tape at the finish line. Ready for reward,
they cluck at my ankles. My fist, full of birdseed,

drops into the flock of feathers: Crockett,
always first place. Romulus and Remus,

indistinguishable, unflappable,
untroubled by second place.

Upon Removing a Bird's Nest from a Porch Light

First, check to be sure it is uninhabited.
Run your fingers inside, slowly, feel for

small heartbeats. Take it down, careful
not to injure the architecture. See mud

lining, smooth, as if thrown by the hands
of a potter, how it makes a perfect bowl.

Marvel at the stitching together of twigs
and weeds, how long it must have taken

beaks to weave this home. What winged
story took place here? What wonder.

Warning

Don't bang that screen door when you go out!
snapped my grandmother from the kitchen,
stringing beans for supper. *I don't,* I yelled back,
letting go the door two feet over the threshold,
hearing it slam as I bounced off the porch
headed to our fort in the woods. This morning
I step out the back door, careful to help the screen
settle snugly into its frame, turning the handle
to lock it shut. I'm on my way to teach. Poems,
I've learned, open doors, too. And let them slam.

In Summer Dark

The last inning of the paper-wad
baseball game, lightning bugs

already visible as we ran the bases:
slam the ball with the dowel rod,

take off to the Burgess's car, then on
to the apple tree (can't see if Stevie

caught the ball or not but keep going)
to the lawn chair, someone yelling,

"It's coming home," but so are you,
grass slippery in bare feet, so slide.

Fashion Update

I see them everywhere these days:
runners streaking by in striped leotards
and Spandex; toddlers, butt-up on the
playground; women in the grocery line.
Students heedless of holes in their knees.
When did underwear become outerwear?
When did crazy triangles and spiderwebs
replace beloved Levi's and our khakis?
Even the birds are dressing up the fledglings.
I swear I saw one flying by in leggings.

Becoming Lizard

Because it's cold in my room
I move out to the concrete stoop
which the sun has been warming
since morning. I spread out on
the pebbled surface, belly down,
arms tucked in close. My toes
rub against the stone. The sun!
The sun lays its hands on my head.
I feel my flannel turn to scales.
If only I had a tail.

Elegy for Crockett

Once there were three
trundling out from under
the cedars that trim the yard.
Now there are two, subdued
but not deterred, eager for
my handful of chicken feed.
Missing, the ginger one, fluffed
and friendly, victim of a mob,
raccoons late Friday night.
Tercet a couplet, unrhymed.

Birthday Poem at 74

The people who remember me as a child
are gone, who remember me before
I had memories of my own, who took
the photos of me holding a Canadian flag
at Niagara Falls and a conch shell at Daytona
Beach. Aunts and uncles, two grandmothers,
both of whom I have outlived, neighbors,
Sunday school teacher, pediatrician, and yes,
my mother, who kept that first memory of me
this very day when I forever changed her life.

Chiroptera

We may be losing bats forever. They starve, exhausted,
a million a year, in places like the limestone caves

of West Virginia, unable to sleep because of white-nose,
no mosquitoes to feed on while they're kept awake.

Rabies, she tells me, in hysterics, *they'll bite my child.*
I shoot the damn things, he spits, *they're ugly as sin.*

The boy points up to the trees, spinning: *Vampires!*
There, the slow-motion unfolding of wings, the swoop

into dusky dark, looping from limbs, from rafters.
Beauty and mystery: too dangerous to foster.

Watching the Numbers,
Hearing the Words

We have poetry / so that we do not die of history.
　　—Meena Alexander

History is underway, COVID-19 deaths
surpassing those of 9/11 and losses
in multiple American wars. The president,
for whom history is rubbish, without him
as protagonist, made up by men he has no
interest in, knows even less about poetry.
Doesn't know about metaphor, has no
sense of form. Can't understand how words
can be a door you open, slowly, rungs on a ladder
that take you out from the collapsing story.

I Want to Ask My Mother

did you ever feel you could not
go on, that the pressures of wife
and mother and daughter and
Sunday school teacher and cook
and secretary caught you in
the undertow of day and night
and day and words could not
keep you afloat but like seaweed
tangled you in ribbons of *must*
and *now* and *late* and *lost*?

How did you sleep when the medical
bills came, when your pregnancy
test came back positive, when college
tuition was due, when one more stone
piled on another stone, then another?
What mortar did you use to sculpt them
to a tower, a lighthouse in the storm,
or a wall holding back the breakers?
I think you would say God was your glue.
I know it was not God; it was something in you.

My Mother's Camels

or some of them, remain on the glass shelves
of the china cabinet just where she left them
twelve years ago. My father tends the herd, dusting
periodically, making sure one does not go missing.
It is easier for a camel to go through the eye of a needle
than for a rich man to enter into the kingdom of God,
my mother told a grandson, thus initiating years
of camel gifts on birthdays and Christmas. She would
be happy we have kept them, reminder not to stuff
our pockets with dollars. Better to want change.

Evolution of a Verb

In the 1950s, we zoomed
down hills on our sleds,

zoomed in circles, reckless
at the roller rink, zoomed

through homework to get
outside before dark.

I Zoom now at my computer,
faces stamp-sized, voices

trapped in tiny squares.
I zoom out. Anywhere.

Little Essay on Form

Think of the football field,
those lines and numbers, structure
for winning, or a corral, horses held
back from their wild instincts
to become wind. The glass
that prevents water from marrying
the sea. The body of the cat
that confines constant improvisation.
The garb we wear for mourning,
to hold in the grief.

Tulips

They arrive, boxed and squashed,
two bunches, sent from a friend
in another state wishing us *Happy
Spring.* They're travel–weary, limp
and thirsty. We give them water
in tall glass vases, loosen their leaves
and stems. I'm not optimistic for
their recovery, but three days later
they are an explosion of bloom,
a western sunset, a pastel song.

Our friend cannot know he sends
these flowers after two deaths
in two weeks, the losses heavy,
our hearts looking for some way
to rise up in this Easter season,
to acknowledge the cycle of death
and rebirth. We look around at
the redbud brilliant after rain,
the forsythia sputtering *joy joy joy,*
these tulips, opening their fisted folds.

How It Happens

Behind every story there is the
event: the joy of reunion, a birth, a death.
We tell the same stories with a different cast of
characters. In this one the man is angry, in that one the
woman remembers how unappreciative of her mother
she was, how she would like to have her back so the hurt
for both of them could disappear like stars at daybreak, the
waves after storm, the ink on the page, which, as a daughter,
she tried to erase, though the difficult words had entered into
her blood. They reappear, like those stars, and this we call poetry.

Ten Lines

In the first one, set the scene.
Line 2, elaborate.
Now, begin to pose the question,
or in 4, give a slight hint where
you might be off to. Pull the readers
in with something known to them.
Not much time left, don't panic.
Line 8 begins the denouement
while 9 slips in the turn that opens
out the poem, an unlatched door.

Making a Joyful Noise

Sitting atop the telephone pole
like some hood ornament from the 1950s,
the pileated woodpecker drums away
at what? Carpenter ants, termites, beetles,
some delicacy hard for us to savor.
Or does he hammer hard because the pole
is there, and so is he, and he's high
in the world, eagle-perched, eyeing
the humdrum ones below, mowing yards,
hanging laundry, not having his good time.

The Last Piece

My father remembers my Aunt Grace
kept a jigsaw puzzle on the card table
in her studio apartment, working in pieces
whenever she felt the urge. Covered bridge
in the country, basket of kittens, containers
of canned goods shelved in the cellar. At 99,
she left her last scene unfinished. When we
collected her things, divided trinkets and
treasures, there were holes in the picture
we couldn't ignore. It wasn't easy, finishing.

Popsicle

There they were, in a smashed box in the back
of the freezer drawer, banana popsicles
from last summer. I don't expect them
to be tasty, even good, but it's a hot June day
in Michigan so I unwrap one, plug it in my mouth
like a pacifier. It's icy, and I'm ten years old,
barefoot on the gravel road, walking back home
with my friend Susan from the Esso station.
It's worth my week's allowance,
so sweet and so cold.

Turn, Turn, Turn

In the woods after rain
the trail is puddle-full, the lime
green of coming spring trims
fallen trees, rotting timber.
The forest flares with growth
despite virus and decay.
Morel mushrooms, little fists
exquisite in form and flavor, nudge
up through the loam. Later, on a stem,
crawls the worm. Still later, the stained-glass wings.

Acknowledgments

My first thanks goes to the late Emily Calhoun who was a wonderful writer and the inspiration for one of my early ten-line poems, "Even the Least of These," which has become the title for this collection. She is very much missed, and I'm saddened that she is not here to see the book that has resulted from her compassion and creativity.

Thanks to Ghost Ranch Conference Center in Abiquiu, New Mexico, for giving me the opportunity to teach a course on the ten-line poem, share the poems I had written with participants, and encourage others to consider the art of the ten-line poem. Also, to the Lansing Poetry Club and Theodore Roethke House for sponsoring workshops where I could present my ten-line poems and, again, encourage others to write them.

Virginia Center for the Creative Arts provided me with space and time to organize the manuscript and cull the fifty poems in this collection from approximately ninety poems I had written during the two years of COVID. Thanks to the writers/artists who shared that time and space with me, listened to the poems, and engaged in conversations that were very helpful.

A very special thanks to Allyson Davidson, our partner in creating this manuscript, for her excellent editorial work and technological know-how without which you would not be holding this book in your hands. Her enthusiasm for this project, her patience with our delays, and her general good humor were invaluable.

To Marcus Fields and the Language and Media Center (LMC) in the Residential College in the Arts and Humanities at Michigan State University, we owe thanks for helping us scan Laura's linocuts and send them to Allyson so that she could incorporate them alongside the poems in the text. He is a kind soul, also with great patience and spectacular photoshopping skills.

———

No artist, no person, ever works alone. They are influenced by their environment and those around them as well as those who came before them. This certainly is the case for me. As an artist, I am drawn to Indigenous art—its honesty, its energy, and its beauty. I am particularly fond of Inuit art and the work of Canada's Cape Dorset Printmakers. Their elegant simplicity, use of high contrast, and whimsy never cease to inspire me. And I return to their work again and again for artistic guidance. If you see similarities (but never plagiarism) between my work and theirs, I am sincerely flattered.

Many galleries across the country have represented and sold my work over the years. And I thank them for their support. Most recently, I have had my work shown at the Lansing Art Gallery, the Nelson Gallery, the Grove Street Gallery and Studios, the Clinton Art Center, the Crooked Tree Gallery, Michigan Artist's Gallery, and the Shiawassee Art Center.

While the majority of the linocuts featured in this collection were a response to Anita's ten-line poems (which flew from her pen faster than I could carve), several were award-winning prints completed earlier. The images alongside "Learning about Nuance" and "Chaos in Spring" fall into this category. It is also worth noting that together the poems and images alongside "Housing Project" and "Watching the Numbers, Hearing the Words" were accepted into the Crooked Tree Gallery's 2021 juried show dedicated to artistic collaboration.

I must also thank the Lansing-area Print Makers Collective (aka Lino Ladies), a group of eleven area artists, all of whom incorporate the linocut into their work. But more importantly, the Lino Ladies meet once a month to share information, provide creative feedback, undertake artful projects, and laugh. I am grateful for their friendship and diverse talents. Here, I must give special thanks to Kate McNenly and Cindy Lounsbery for applying their graphic-designer skills to so many of my "almost ready for prime time" projects.

Doug DeLind deserves a ginormous thank-you for being such a steadfast and loving supporter of me and my work. In addition, he deserves a thank-you for framing my prints, making my packing boxes, and

schlepping my artwork about town. His alternative artistic perspectives and suggestions are often spot on and generally well tolerated.

And finally, but no less sincerely, I want to thank both Allyson Davidson and Marcus Fields. Allyson, as Anita has mentioned, saw the potential of our verbal and visual collaboration and offered to use her talents to make our collaboration publishable. Similarly, Marcus took the time to scan and format each print in this volume. He did this while working full time at Michigan State University and earning his MA in educational technology. Both need a standing ovation.

———

This publication was made possible in part thanks to the generous support from the Residential College in the Arts and Humanities at Michigan State University, Everybody Reads Bookstore in Lansing, Michigan, Beth Alexander, and several anonymous donors.

About the Authors

Anita Skeen is currently professor emerita in the Residential College in the Arts and Humanities at Michigan State University where she is the founding director of the RCAH Center for Poetry at Michigan State University and the series editor for Wheelbarrow Books. She taught students in kindergarten through high school while working with the Kansas Arts Commission's Artist in the Schools Program; in traditional venues such as college classrooms as a visiting writer and writer in residence; and in senior citizens' centers, libraries, and at Ghost Ranch in New Mexico for over forty years.

She is the author of six volumes of poetry: *Each Hand a Map* (1986); *Portraits* (1990); *Outside the Fold, Outside the Frame* (1999); *The Resurrection of the Animals* (2002); *Never the Whole Story* (2011); *When We Say Shelter* (2007), with Oklahoma poet Jane Taylor; and *The Unauthorized Audubon* (2014), a collection of poems about imaginary birds accompanied by the linocuts of anthropologist and visual artist, Laura B. DeLind. With Taylor, she coedited the literary anthology, *Once Upon A Place: Writings from Ghost Ranch* (2008). Her poetry, short fiction, and essays have appeared in numerous literary magazines and anthologies. Collaboration is an important aspect of her work, and she currently is involved in writing projects with poets Jane Taylor and Cindy Hunter Morgan.

Laura B. DeLind earned her PhD in anthropology at Michigan State University where she worked for over forty years. As an anthropologist, she is recognized internationally for her work in alternative agriculture and local food and farming. Her research and professional writing appear in numerous books and journal articles and led to her receiving a Lifetime Achievement Award from the Agriculture, Food, and Human Values Society.

As an artist, she has always been fascinated by Indigenous art and artistic expression, especially Inuit art. After her retirement, she has devoted herself full time to printmaking. The linocut offers her an

opportunity to explore the endless interactions of positive and negative space. She also enjoys the linocut's affinity for high contrast and spontaneity. Her work appears in galleries and private collections nationally. She lives, works, and teaches printmaking in Mason, Michigan. To see more of her work, check out her website at https://linocutsbylaurabdelind. squarespace.com.